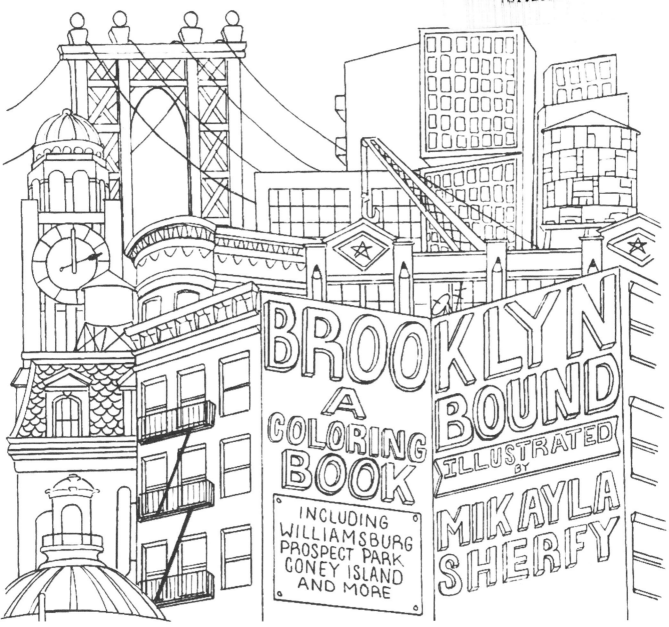

BROOKLYN
A COLORING BOOK
BOUND
ILLUSTRATED BY
MIKAYLA SHERFY

INCLUDING
WILLIAMSBURG
PROSPECT PARK
CONEY ISLAND
AND MORE

ULYSSES PRESS

Published by:
Ulysses Press
PO Box 3440
Berkeley, CA 94703
www.ulyssespress.com

ISBN: 978-1-64604-509-9

Printed in the United States
10 9 8 7 6 5 4 3 2

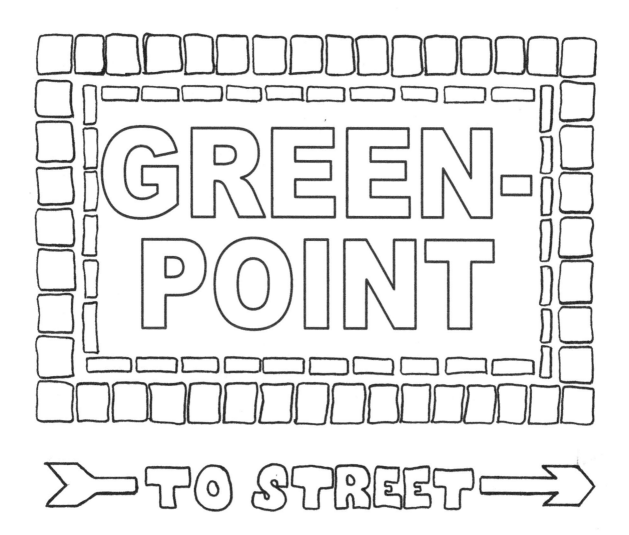

GREEN-POINT

>—TO STREET—>

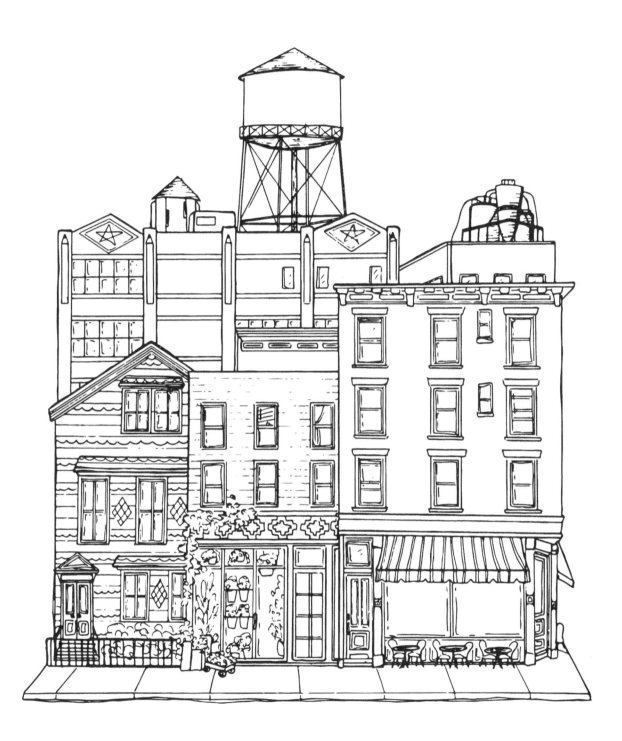

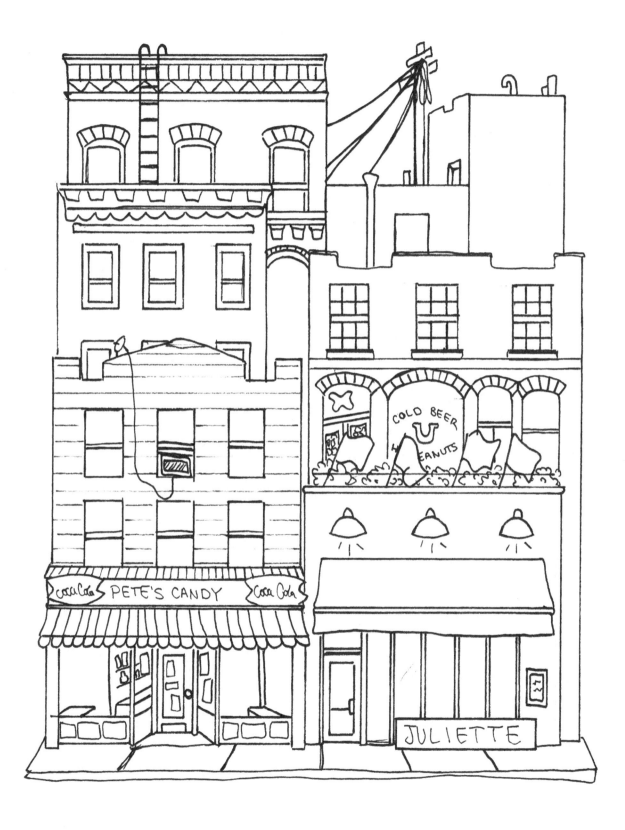

BUSH-WICK

TO STREET →

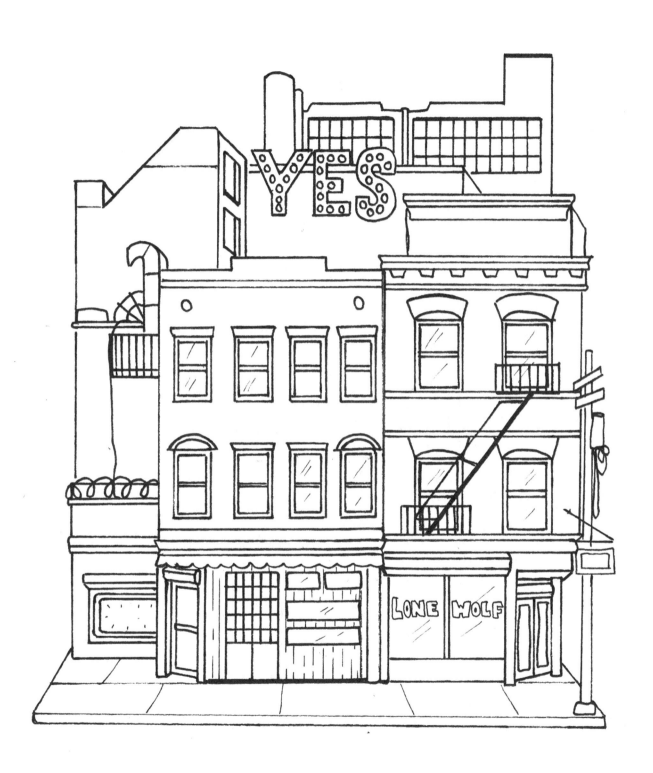

NAVY YARD

TO STREET →

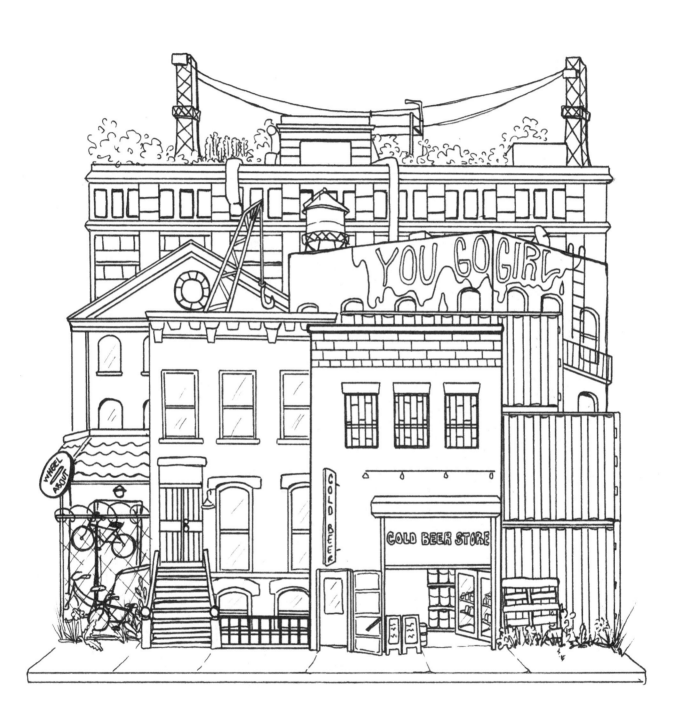

BROOKLYN HEIGHTS

TO STREET →

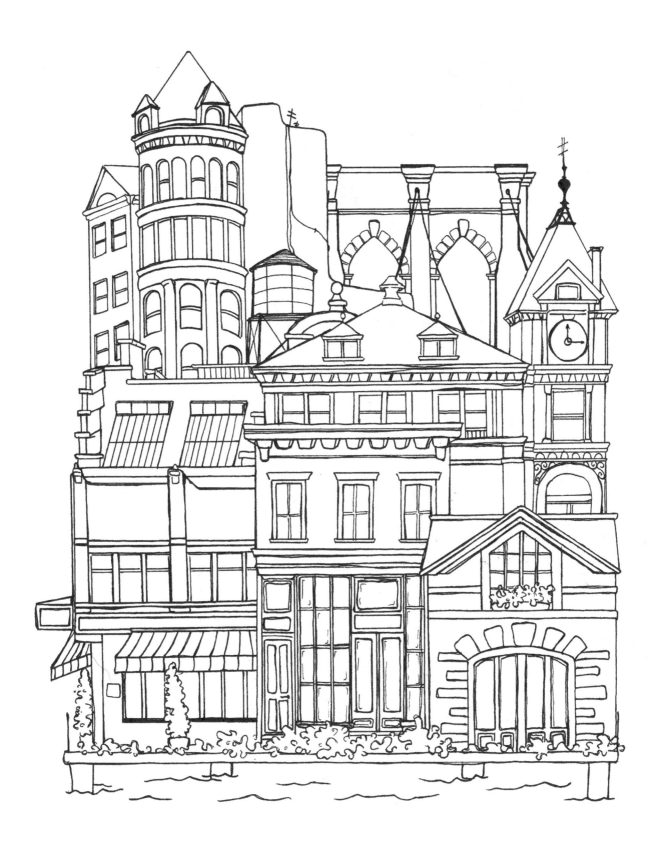

DUMBO

→ TO STREET →

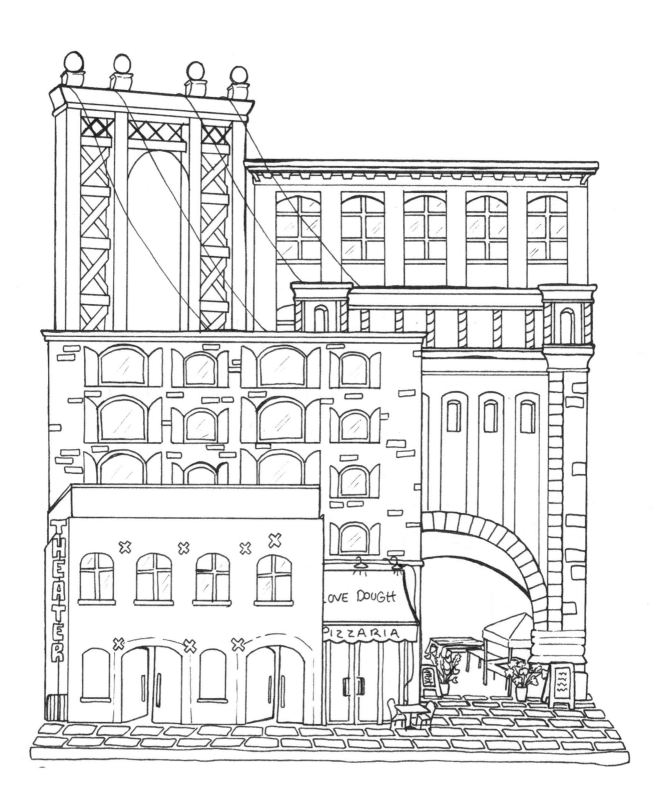

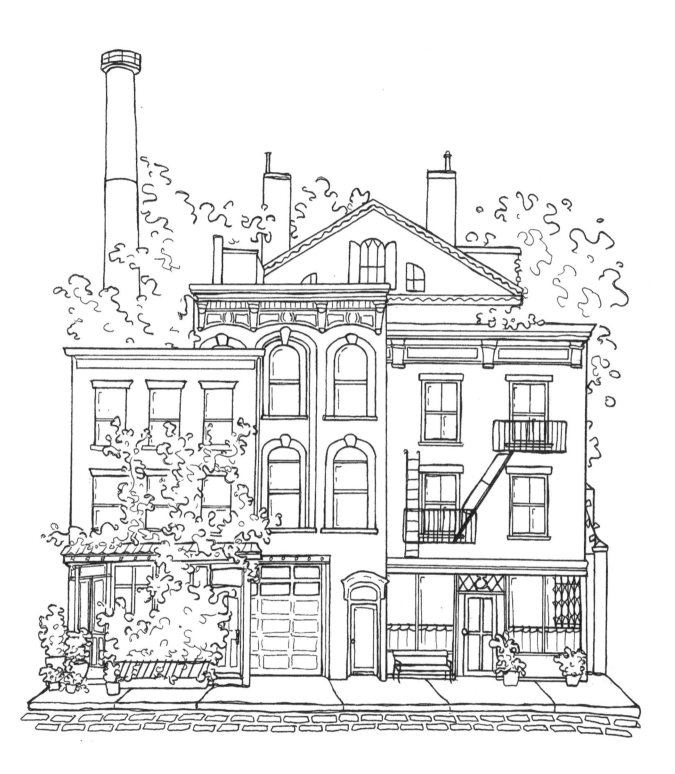

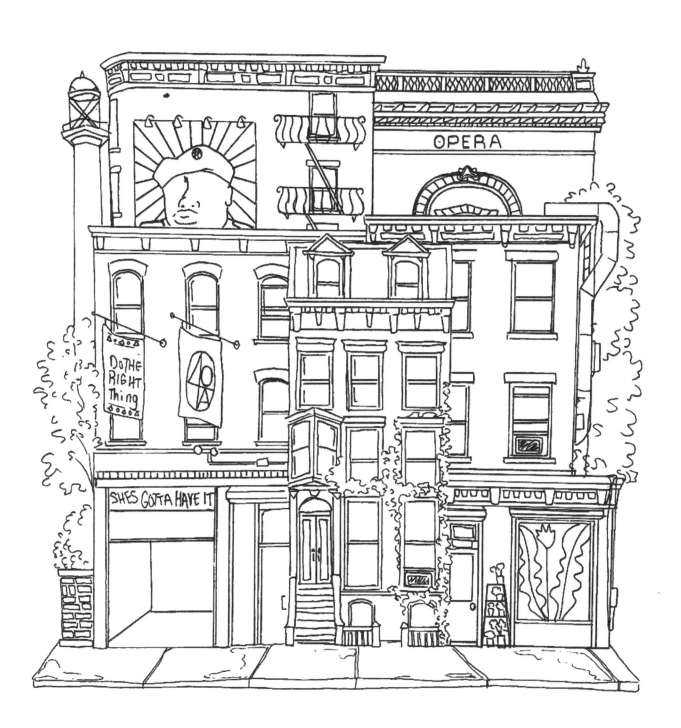

CLINTON HILL

TO STREET →

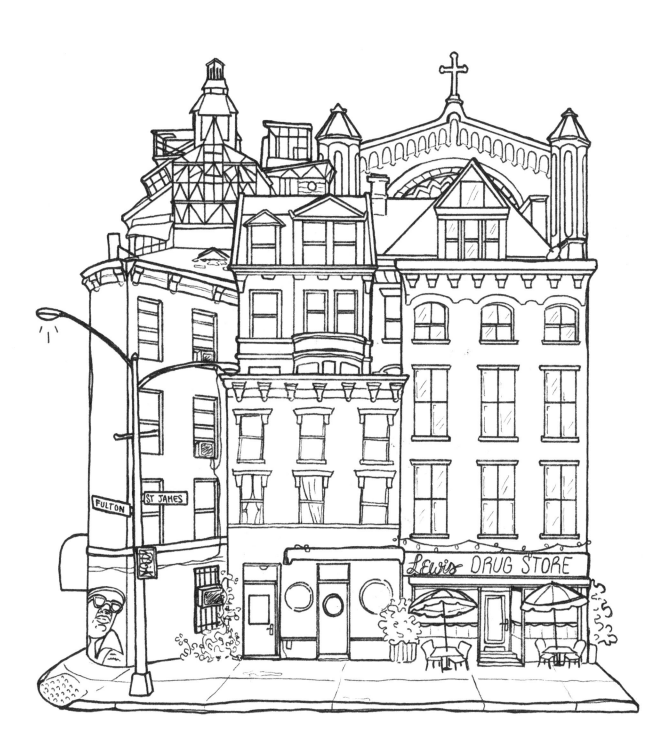

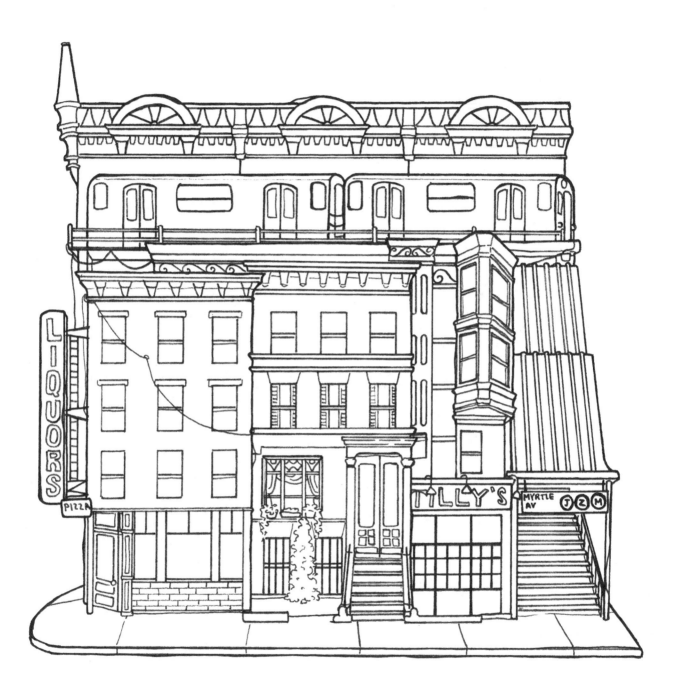

COBBLE HILL

＞━TO STREET━➔

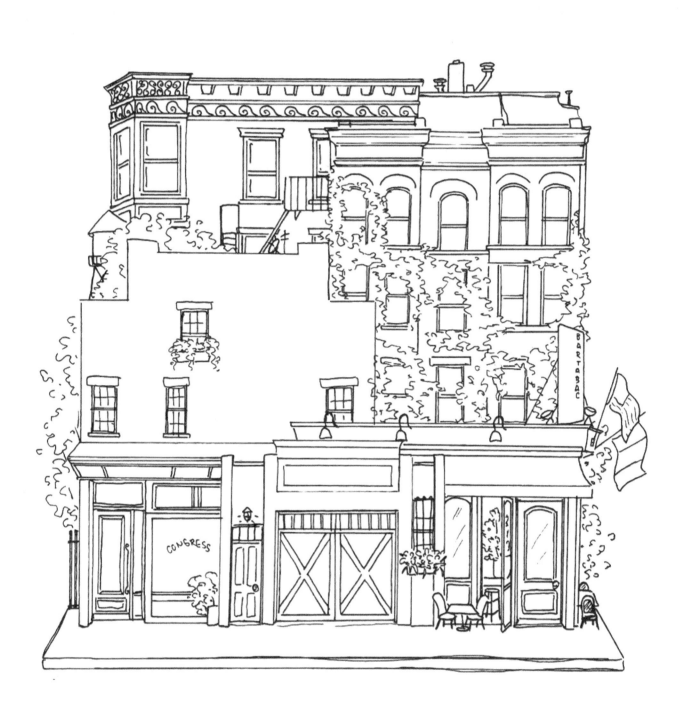

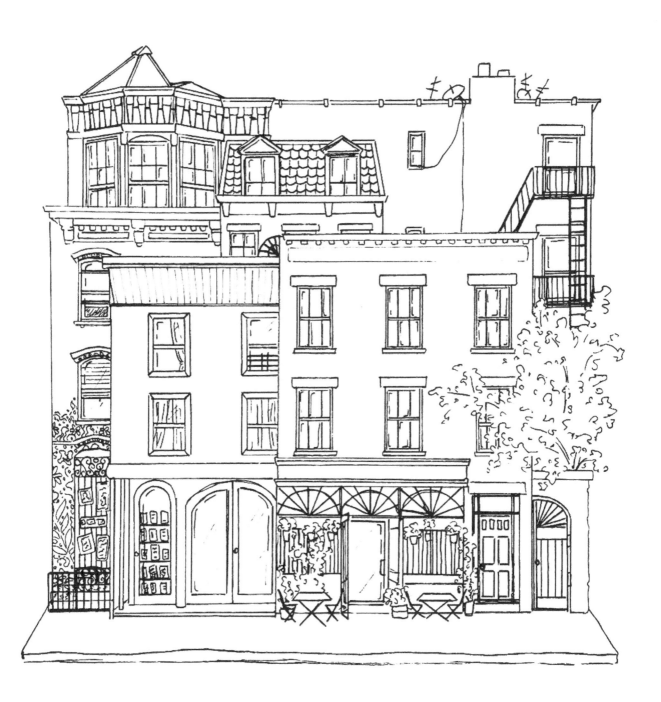

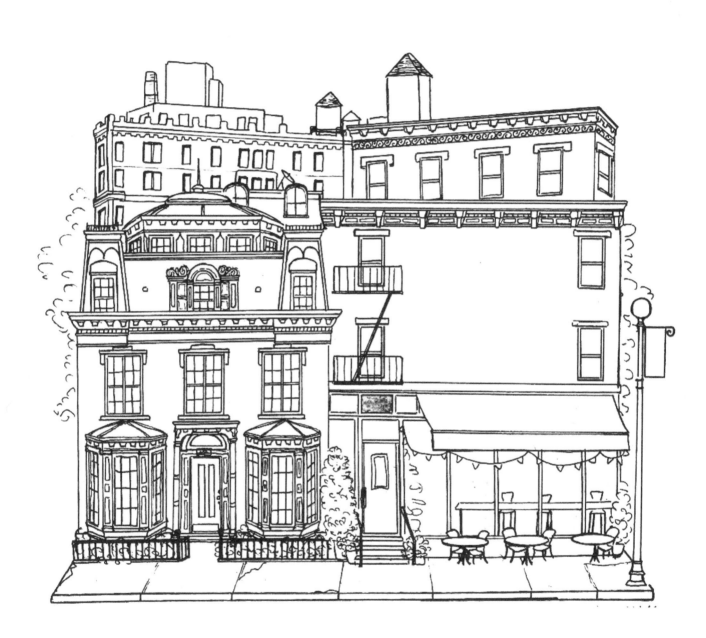

PROSPECT HEIGHTS

TO STREET

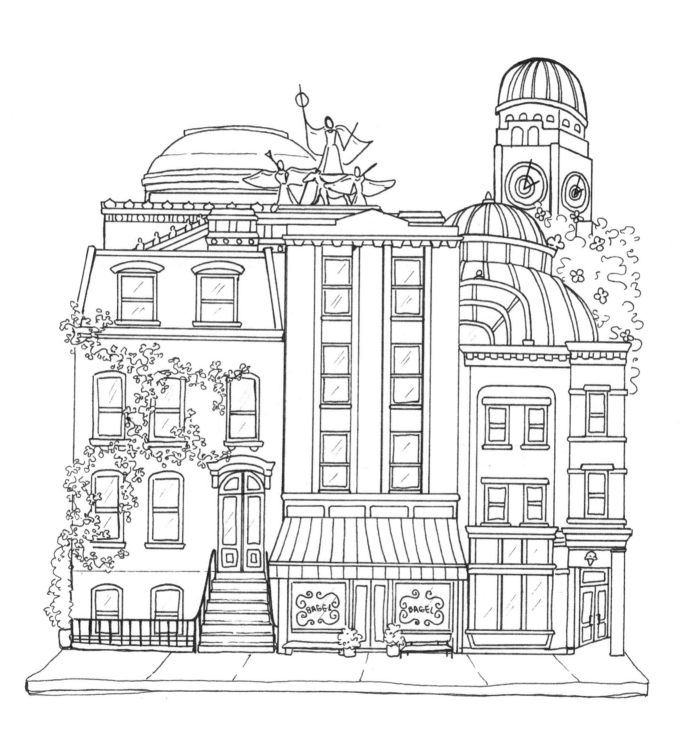

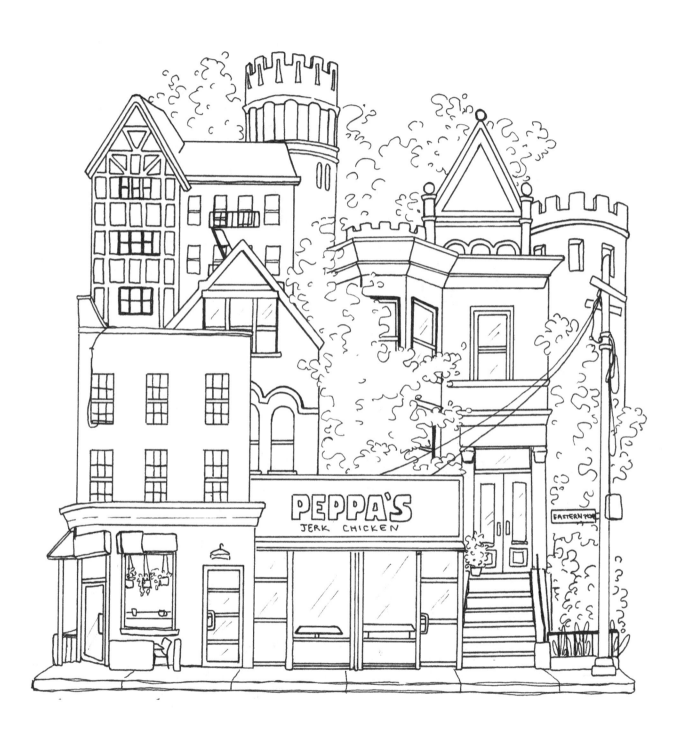

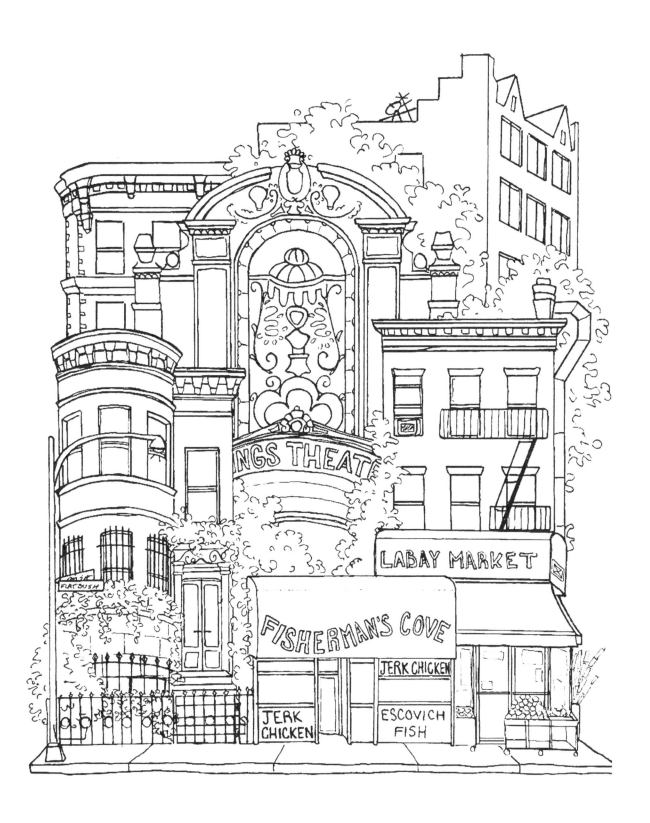

GOWANUS
TO STREET →

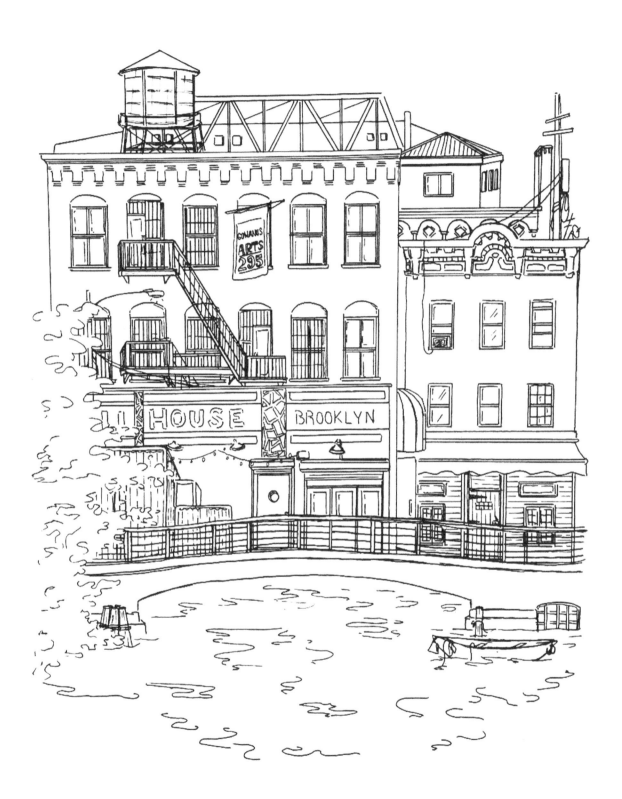

RED HOOK

>—TO STREET—>

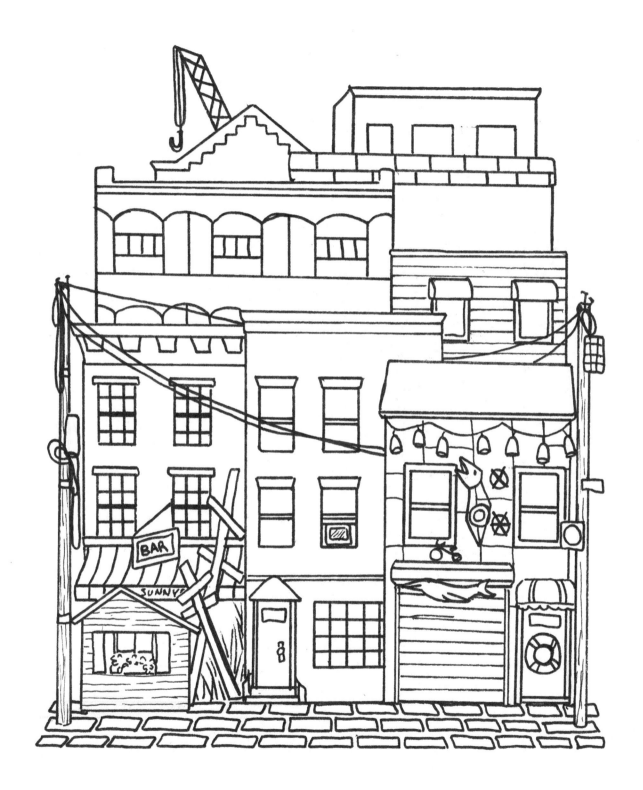

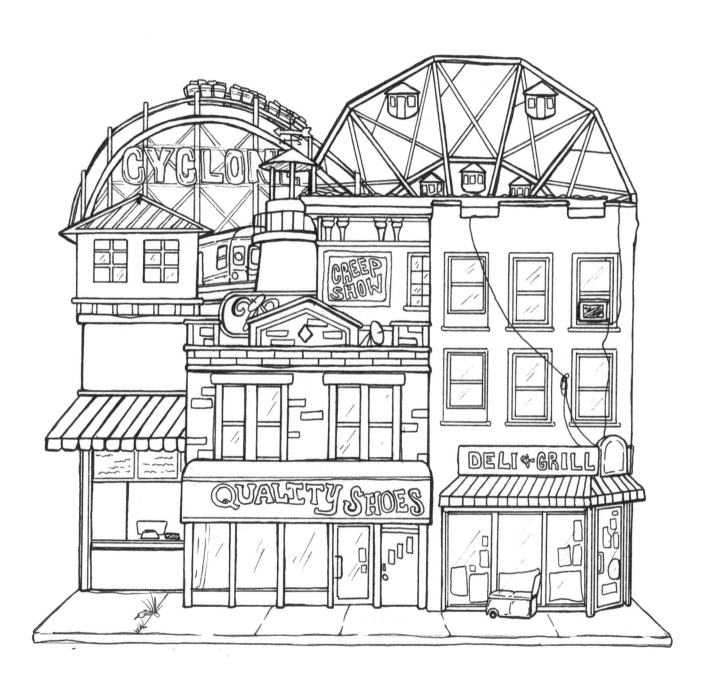

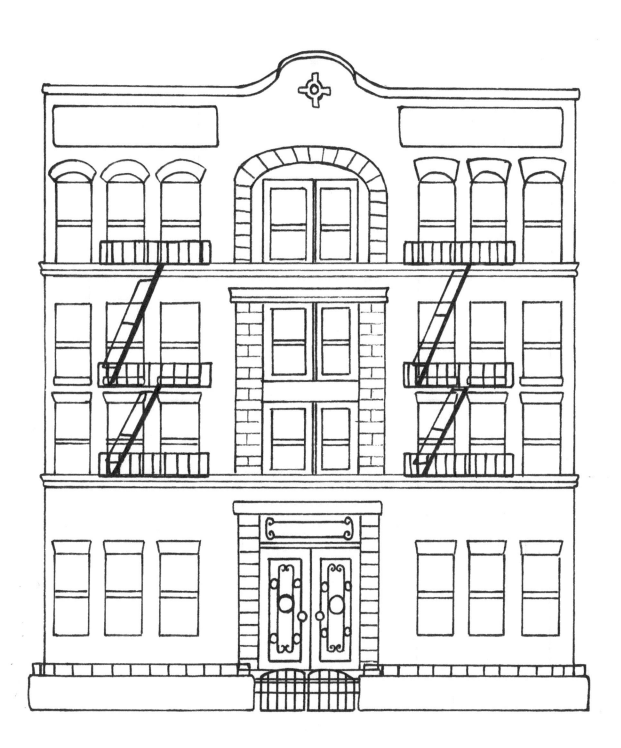

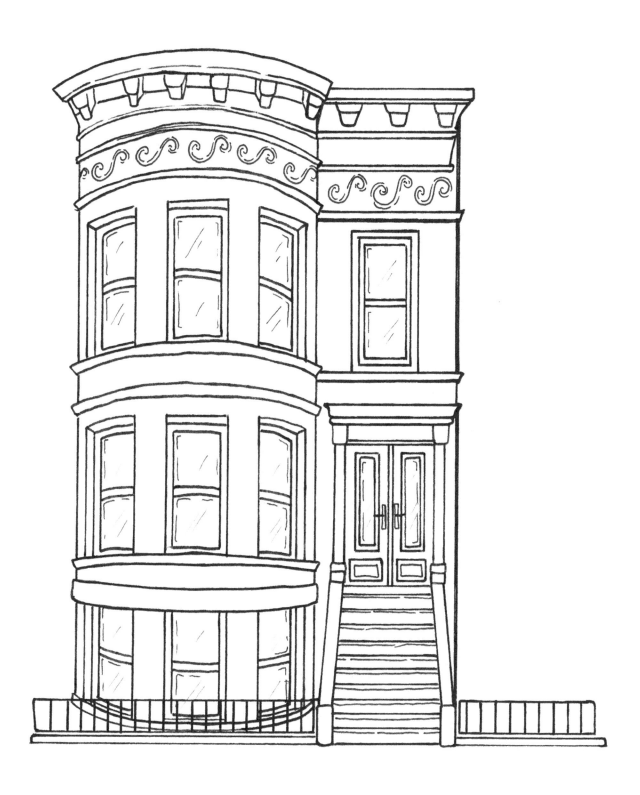

ELEVATED TRACK

FERRY

MANHATTAN BRIDGE

>>—TO STREET—>

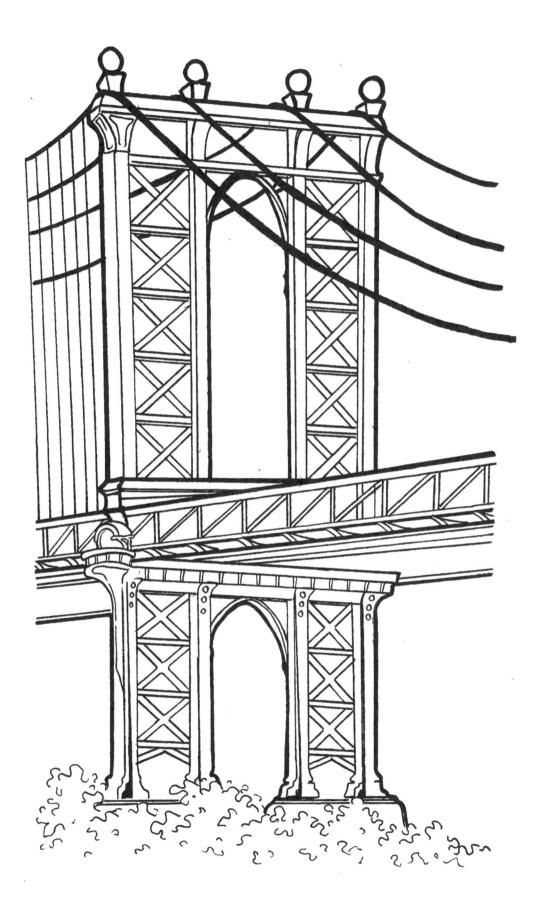

ABOUT THE ILLUSTRATOR

Mikayla Sherfy is an artist based in Brooklyn, New York. After moving from Missouri, where she was raised by a family of artists, Mikayla found inspiration in the beautifully complex NYC cityscape. She has been illustrating and painting it ever since, and her illustrations can be seen displayed in shops, offices, and galleries all around NYC. She never tires of exploring Brooklyn and has lived in many of the borough's neighborhoods, including the Navy Yard, Sunset Park, and Flatbush. Mikayla now lives and works in Greenpoint with her partner Adam and their dog Ferris. This is her first book.